C000224546

MACCLESFIELD
HISTORY TOUR

I would like to thank Ron Frost who allowed me access to his large collection of photographs and postcards. Neil Boothby of Macclesfield Town FC for providing the photo of the team. Anna Rhodes, the Collections Manager at Macclesfield Museums. Katherine Smith of Arighi Bianchi for the photographs of the store. I would like to thank my lovely wife Rose for her patience during the not inconsiderable time it took to complete the book.

Front cover photograph: Macclesfield Town Hall
Back cover photograph: Waters Green

First published 2016

Amberley Publishing
The Hill, Stroud,
Gloucestershire, GL5 4EP
www.amberley-books.com

Copyright © Paul Hurley, 2016
Map contains Ordnance Survey data
© Crown copyright and database
right [2016]

The right of Paul Hurley to be
identified as the Author of this work
has been asserted in accordance with
the Copyrights, Designs and Patents
Act 1988.

ISBN 978 1 4456 5585 7 (print)
ISBN 978 1 4456 5586 4 (ebook)

British Library Cataloguing in
Publication Data.
A catalogue record for this book is
available from the British Library.

Typesetting by Amberley Publishing.
Printed in Great Britain.

INTRODUCTION

To start this look at the history of the town of Macclesfield, we have to begin on the other side of the world in China. There is a famous road that starts in this far-off country but what is perhaps less well known is that this road leads to Macclesfield. This was recently made official by the United Nations World Tourism Organisation when they ruled that this famous route begins in the once-ancient capital of China, Xi'an and ends in Macclesfield. (We recently visited China and watched at close hand the spinning of silk from the cocoons of the silk worm.) The manufacture of silk products started in China in 3,500 BC and exhibits illustrating this can be seen in the Macclesfield silk industry museums.

Macclesfield is known as Silk Town due to the town's involvement in the silk industry that started in the eighteenth century. At its peak many large impressive mills could be found around the town, some of which still survive today but with other uses. The town became famous in the 1500s as a silk-button manufacturing centre and later became world famous for silk throwing and hand weaving, an occupation that was carried out in the mills and in some cases the old-fashioned way, in attic rooms, known as 'garret houses'. In 1814 Macclesfield had about thirty mills and ten years later there were over seventy; these were the town's busiest years, as after 1870 very few mills were built.

But let us go back even further in Macclesfield's history as it once was one of the most important towns in Cheshire. The town appeared in the Domesday Book as Maclesfeld, 100 years later it was recorded both as Maklesfeld and Makefeld. In ancient terms 'feld' meant open space; the first part of the name probably related to a person, in this case someone called Macca, so we have Macca's Field. Eventually Macclesfield became the name that it bears today. The town is in a very picturesque position situated as it is on the border of the Peak District and the road into Derbyshire. The town was once, like Chester, surrounded by walls, ramparts and gates, namely the Jordan Gate, the Chester Gate and the Church Wall Gate. Streets in the town today commemorate these

gates in Chestergate, Jordangate and Back Wallgate. The destruction of these walls took place during and after the English Civil War (1642) when the town was initially held by Sir Thomas Aston and his Royalists. Damage was caused to the castle and walls during the bombardment of the town and its subsequent taking by Sir William Brereton and his Parliamentarians. The final destruction of the walls was ordered after the war by Cromwell and his Council of the Commonwealth.

As mentioned previously, Macclesfield did once have a castle that went by the name of Macclesfield Castle, Buckingham Castle and even Buckingham Palace. This was constructed in 1398 by John de Macclesfield, the keeper of the King's Wardrobe. The title 'Castle' may have been a bit pretentious for what was a large manor house situated on four plots on the east side of Mill Street. It was, however, the most important and impressive house in Macclesfield. It was later owned by two families of Earls but by 1585 it was described as 'ruinous'. Although a room was used as a Catholic church in the late eighteenth century, the only part of it that survived into the twentieth century was the porch that, despite appeals for its preservation, was demolished in 1932 and the land used for building. To explain the names Buckingham Palace and Buckingham Castle, in 1444 the land passed to the Dukes of Buckingham.

During the medieval period Macclesfield was much smaller. If you wish to 'walk the bounds' of this small and ancient town, start by walking down Mill Street then down Derby Street, across Chestergate and King Edward Street. Then bear east just beyond Cumberland House and the circuit can be completed by crossing Jordangate just north of Pear Tree House, now Jordangate House, returning to the Market Place at the top of Brunswick Steps. You will then have circumnavigated old Macclesfield Town.

Later in the days of stage coaches Macclesfield was a stopover town for the coaches that travelled the London to Manchester road. Some of the coaching inn buildings survive, for instance the Macclesfield Arms in Jordangate, now offices and the Flying Horse Inn on Chestergate, now a pound shop. Then came the canals, namely the Macclesfield Canal built by Thomas Telford and opened in 1831. It was built to connect with the Peak Forest Canal at Marple and the Trent and Mersey at Talke in Staffordshire. This was one of the later canals having been built not that long before the railways arrived. The Macclesfield branch of the

Manchester and Birmingham Railway was completed less than twenty years after the canal was opened. The heydays of the canal network were already in decline when Macclesfield's was built.

The town is the original home of Hovis bread. The company was founded by a Macclesfield businessman and baker, originally from Stoke-on-Trent and produced at Publicity Mill, but better known as the Hovis Mill situated on the canal by Buxton Road. The word *hovis* is thought to have originated from the Latin *homo vitalis* meaning 'strength for man'.

Included within these pages are many churches and chapels as well as the old West Park Hospital, once the workhouse but still part of the Health Service. What has now been demolished is the massive Parkside Mental Hospital that was situated on Victoria Road, but in the history of Macclesfield, well worth a mention. It was built from 1868 to 1871. It then had the now politically incorrect name of The County Lunatic Asylum. Later additions gave it its own infirmary, a facility for difficult cases, a new wing for epileptic patients, a church and an isolation hospital. There were also a 60-acre farm, workshops and laundry. All of these additions were before 1900, making it one of the largest of its kind in Britain. It could accommodate around 800 patients. It closed in 1997 and most of it was replaced with a housing development. But enough of the introduction; let's have a look around Macclesfield in words and pictures

But before we start our history tour of Macclesfield, let's look at the four sites open to anyone who has an interest in the local history of the town:

The Silk Museum – in what was the old Art School Building on Park Lane

The Paradise Mill also on Park Lane

The Old Sunday School in Roe Street

The West Park Museum in West Park off Prestbury Road

Macclesfield is a town that is very well served with heritage sites and excellent museums and all will be featured within these pages.

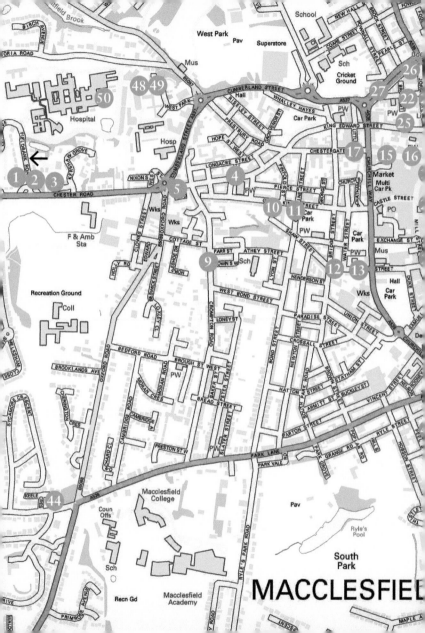

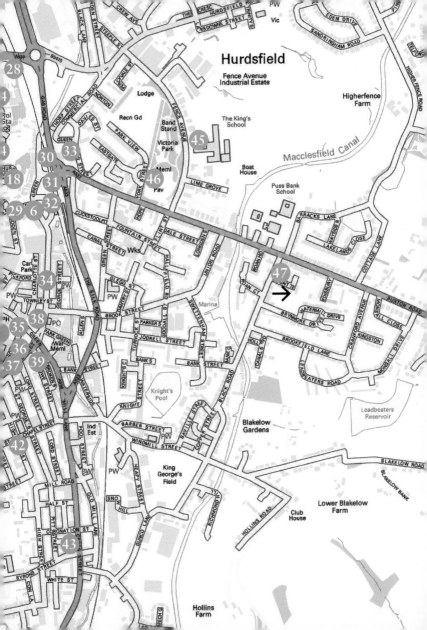

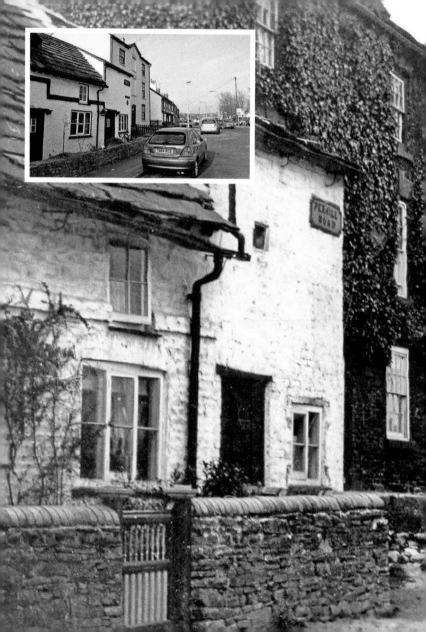

1. PEXHILL ROAD *c.* 1920s AND BROKEN CROSS

We now start our proper tour of the town of Macclesfield from the direction of the lovely countryside that can be found on the roads from Holmes Chapel and Knutsford. As we pass along Pexhill Road with its ancient cottages we find the suburb of Broken Cross. Nos 3 and 5 Pexhill Road are Grade II-listed buildings that date from the late seventeenth century and can be seen in the old photograph. Little has changed here over the intervening years, although one house has disappeared and the large one has lost its verdant coat. The Bull's Head in the distance is yet to be modernised. There was once a cross here or perhaps the name is due to the fact that this has been a crossroads for around 1,000 years. Either way, as we pass along Pexhill Road we come to what is now a roundabout and has been so for some time. The car in the old photograph would indicate that it is in the 1920s.

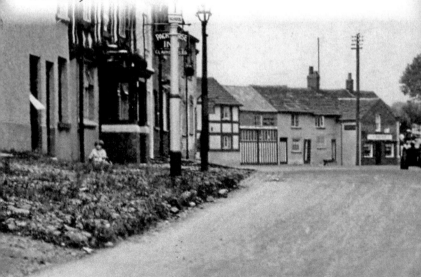

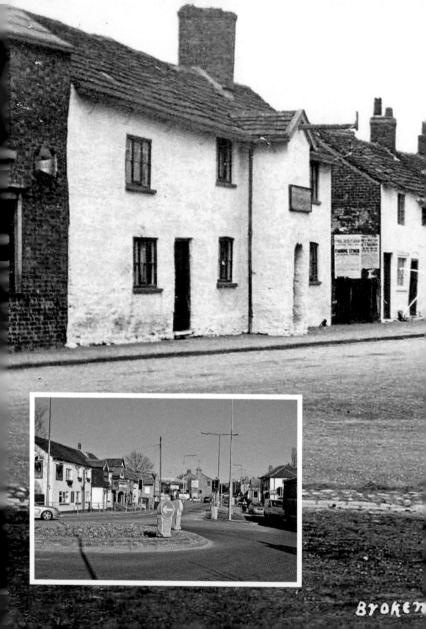

BYOKEN

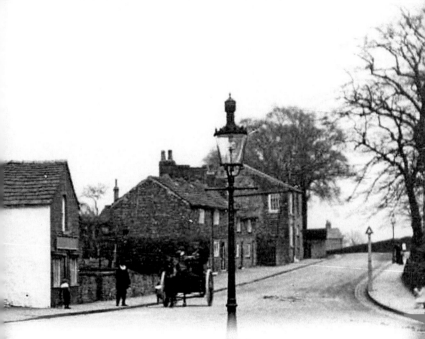

2. BROKEN CROSS *c.* 1900 AND 2016

Standing by the roundabout at this busy intersection, we get a view of what it looked like at the turn of the last century and see the difference in the recent one. The Bull's Head pub is at least 200 years old and was serving ale when the road upon which it stands was the Chester Turnpike and nearby was the toll gate. As can be seen by comparing the photographs, it has been altered quite drastically over the years. There have been some alterations to the front of the pub and the buildings around it. There is a remodelled front and the roof has been modernised.

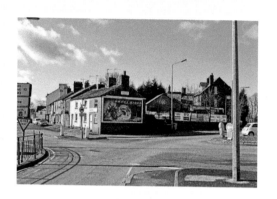

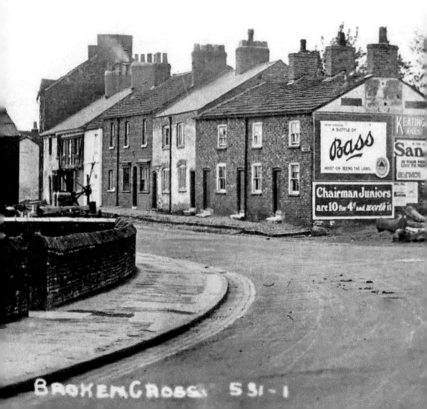

BROKEN CROSS 531-1

3. BROKEN CROSS c. 1920 TO 1930

Turning and looking back into Pexhill Road, is an old view that is filled with period advertisements. Some of the buildings have been demolished for road widening including the one with the impressive clock. This clock is similar to the one that is now across the road and can be seen in the modern shot on one of the newer buildings. The barn with the clock may have gone to make way for the roundabout but the large house at the rear of them is still there, as are the cottages.

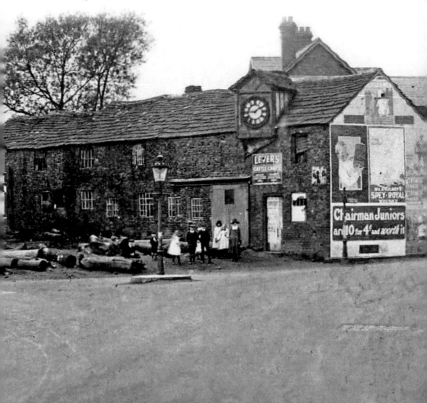

4. CATHOLIC CHURCH OF ST ALBAN 1900s AND 2016, CHESTER ROAD

Coming into town from the Chester Road direction, we arrive at a little-changed area with the Catholic Church of St Alban in the distance. The parish dates from 1799 when the church was St Michael's Chapel and the present church was built between 1838 and 1841. This was at a cost of around £8,000 most of which was donated by the Earl of Shrewsbury. It was designed by the famous architect Mr August Welby Pugin. This man's extensive portfolio of works included many religious institutions and buildings and include the interior of the Palace of Westminster (Houses of Parliament). The roof appears unfinished but that is how it was intended, being described at the time of building as 'an incomplete tower'. Note that the small building with the sloping roof on the right has been rebuilt. St Alban is venerated as the first recorded British Christian martyr and one of four from Roman Britain. He is traditionally thought to have been beheaded during the third or fourth century in the town of St Albans where his shrine is in the cathedral there. Macclesfield's St Alban's Church is a Grade II-listed building.

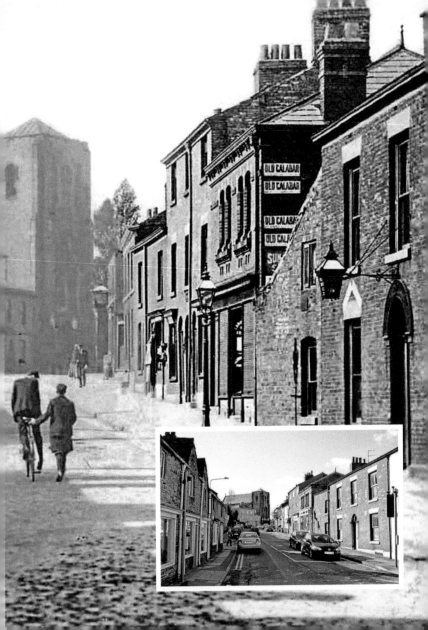

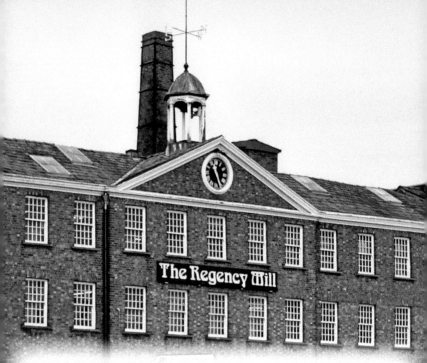

5. REGENCY MILL

Before continuing into the town centre we should take a look at an example of one of the many highly attractive old mill buildings that still adorn the streets of Macclesfield. Like this one, Regency Mill, many are silk mills and this one is located at the junction of Chester Road and Oxford Road. It is still there and is a beautiful building now used for other industries. The mill was built in around 1820 although the carving above the door gives the date as 1790. It was an integrated site that included silk manufacture, throwing, dying and weaving. The original occupiers of the silk mill were Hapgood & Parker and there was a bell that would call the workers to the mill. It was later converted to the manufacture of cards and became known as the Card Factory.

6. 108 STEPS

These steps take the pedestrian from St Michael's Church down to Waters Green; they are quite steep and the fitter residents use them to jog up. The age of the steps is unknown but it is believed that they predate 1700. At the bottom of the steps can be seen the Nag's Head public house. Over the years this eighteenth-century pub was altered and originally looked a lot different to today. Next door to the Nag's Head can be found the Waters Green Mill, another of Macclesfield's many silk mills and one of the later ones that postdates the pub.

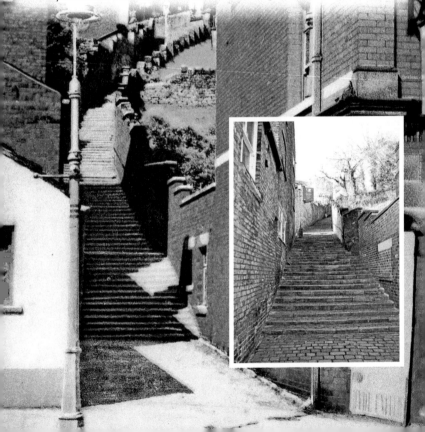

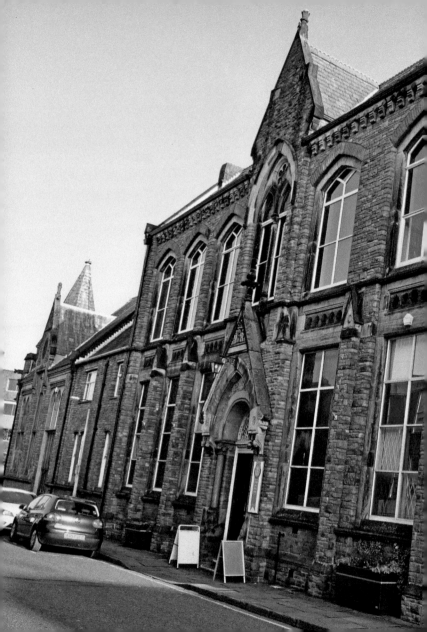

7. THE SILK MUSEUM, PARK LANE I

Now in the town and we first visit the Silk Museum that can be found on Park Lane. It was once the Macclesfield School of Art and was built in 1877 to train designers for the silk industry. Throughout the book there will be mentions of the Macclesfield Useful Knowledge Society. This was formed in 1835 to further the knowledge of the local working population and its premises on Park Green were used for the purpose. Known formally as the Macclesfield Society for the Promotion of Useful Knowledge and later still, the Mechanics Institution.

One of the facilities that could be found within the building was the school of design. By 1873 they had trained seventy-seven designers and 145 weavers. It was time to expand and the building now housing the Silk Museum was the result. The exhibits and artefacts combine to lead the visitor on the full journey through the industrial process of silk making. In the words of the museum descriptive, you can explore silk from the cocoon to the loom, with plenty of hands-on exhibits for children and adults alike. The museum houses a permanent exhibition which explores the properties of silk, design, education, Macclesfield's diverse textile industries, workers' lives, Macclesfield silk during the war and historic machinery – as well as hosting temporary exhibitions.

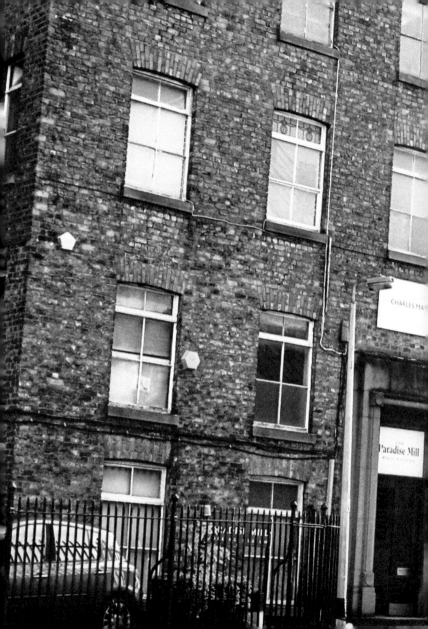

8. THE PARADISE MILL, PARK LANE II

Still in Park Lane we stop to explore this silk mill, built in 1862 and that continued to weave silk up to 1981. It was later turned into another silk museum and has also become one of Macclesfield's most popular attractions. Having been a working silk mill until quite recently, it was easy to replicate what life would have been like and this has been enhanced by atmospheric exhibitions and room settings that give the visitor a perfect insight into what a working mill would have been like during the 1930s. Guides demonstrate the intricate processes of weaving, using one of the twenty-six restored Jacquard handlooms. The tie silk made on such looms was some of the finest ever made in Macclesfield. The town has had, over the years, in the region of 120 textile mills so to give them all a mention would require a dedicated book.

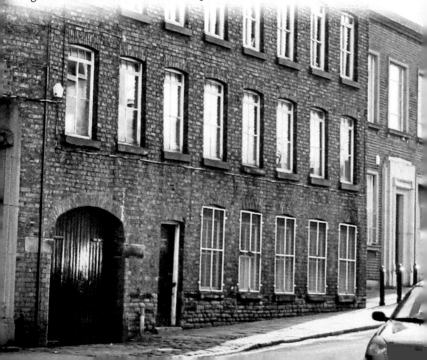

9. MILITARY BARRACKS, DATE UNKNOWN AND IN 2012

We are in Crompton Road now where we find this old Militia Barracks. It was built between 1858 and 1859 at a cost of £13,000 and was designed by Mr Pownall of London and local architect Mr James Stevens. The barracks took the form of a gateway as shown in the photographs, and within were a number of buildings and a parade ground. The barracks housed the accommodation for officers, men and the CO, together with an armoury and training facilities. In 1896 they were occupied by the 4th Battalion the Cheshire Regiment (2nd Royal Cheshire Militia). After a spell as a nightclub, some of the buildings where demolished with the remainder put to residential use.

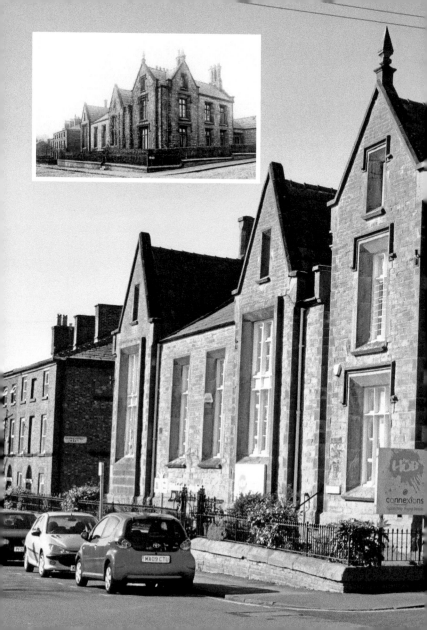

10. MODERN SCHOOL GREAT KING STREET, UNDATED AND IN 2012

These buildings were opened in 1844 as a modern school with more commercial and technical subjects to complement the classical priorities of the parent school, the grammar school. Land from the King's School was sold in order to purchase and build this school at the junction with Bridge Street. It is interesting to note the profuse growth of ivy on the wall in the old photograph. In 1910 the grammar school in King Edward Street was combined with this modern school under the name King's School. In 1854 the grammar school moved to its present location in Cumberland Street. Now this building is used by community agencies.

11. CHRIST CHURCH

This church building is situated in Great King Street and was built between 1775 and 1776 by the local industrialist Charles Roe. Charles Rowe was an evangelical Christian who was married three times, his first two wives dying in wedlock. Roe invited David Simpson to Macclesfield where he became the curate of St Michael's Church and at the time the congregation of St Michael's was outgrowing the building. David Simpson was deprived of the curacy because of his leanings to Evangelism. Charles Roe then built Christ Church for Simpson who became its first vicar. The church tower was built in 1776 and seems out of proportion, being very tall; the clock face on the tower can be seen from all around the area. The Church of England minister John Wesley occasionally preached in the church and was a close friend of David Simpson. Both Roe and Simpson have monuments dedicated to them within the church. The church closed in 1981 but is still consecrated and can be used for services.

Roe Street in Macclesfield is named after Charles Roe and it is the street that houses the Old Sunday School Heritage Centre. For more information on the life of this Macclesfield entrepreneur, a display can be seen at the West Park Museum.

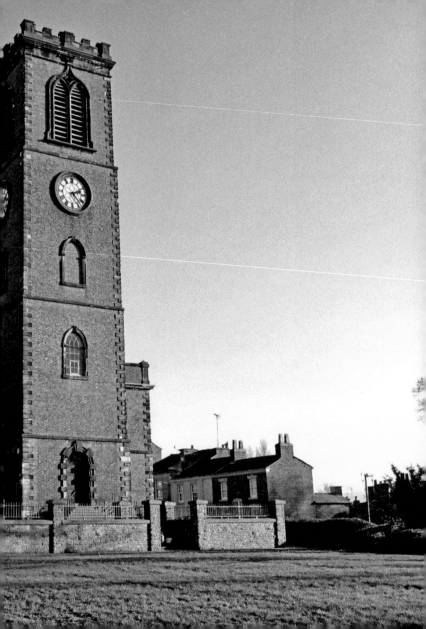

12. THE OLD SUNDAY SCHOOL, ROE STREET

We go along the modern Churchill Way and into Roe Street to find the old Macclesfield Sunday school that started in 1796 as a non-denominational Sunday school in Pickford Street, which catered for forty children. It was founded to 'lessen the sum of human wretchedness by diffusing religious knowledge and useful learning among the lower classes of society'. Though various chapels set up their denominational schools, the Sunday school committee in 1812 elected to erect a purpose-built school on Roe Street. The Big Sunday school had 1,127 boys and 1,324 girls on its books when it opened.

Sunday schools were first set up in the 1780s to provide education to working children on their one day off from the factory. It was supported by many clergymen. The aim was to teach the youngsters reading, writing, ciphering and naturally a knowledge of the Bible. It was not until ninety years later with the introduction of the Education Act in 1870, that children could attend schools during the week. The Old Sunday School closed in 1973 at which time the children attending had decreased from a high of 2,451 to a low of fourteen. The Grade II-listed building was restored with the help of the Heritage lottery fund and now has multiple uses which include a museum and Victorian school room.

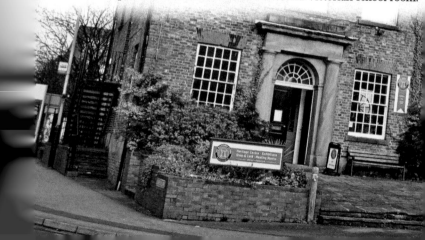

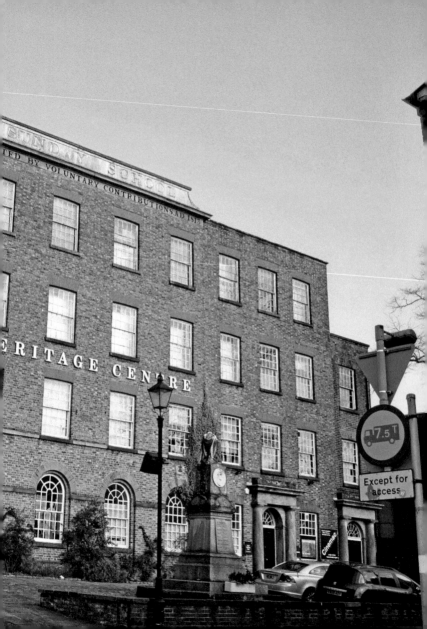

13. ROE STREET CHAPEL AND ST GEORGE'S CHAPEL

An independent chapel was built in High Street in 1824 but it was not until 1834 that it was consecrated as St George's Church according to the rights of the Church of England. A fact not welcomed by a lot of the congregation who, during this time formed a breakaway Dissenting group. (St George's ceased to be a chapel in the twentieth century and is now offices; see inset.) The dissenters, after worshiping for a time in Townley Street, purchased a plot of land in Roe Street and built this building as their own Dissenting chapel and it was opened in May 1829. It was known as Kidd's Chapel as the first minister was Mr G. Barrow Kidd. In 1926 the congregation united with Frost's chapel on Park Green to form Macclesfield's Congregational Church. Over the years the congregation drifted away and the building spent time as the parish hall for St Alban's Catholic Church, and in the middle of the century it became a dance hall but has now returned to religion as the Macclesfield Salvation Army Citadel.

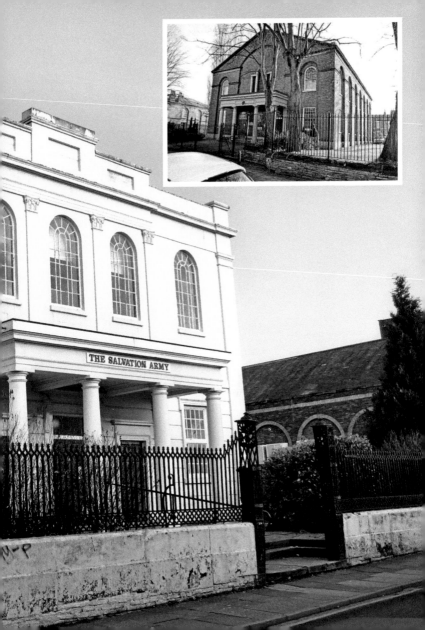

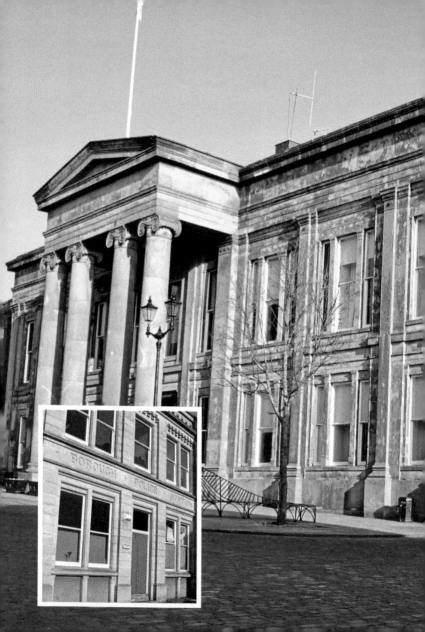

14. MACCLESFIELD TOWN HALL 2016 AND FORMER BOROUGH POLICE STATION

Crossing Churchill Way we come to the centre of the town and the impressive Town Hall. The main building with its ionic columns was built between 1823 and 1824. It was designed in Greek Revival style by the architect Francis Goodwin. At this time the front with similar ionic columns was built with a longer front pointing west towards the church. In 1869–71 it was extended in a similar design by James Stevens with pillars facing Chestergate. It has a large assembly room containing six similar ionic columns running along each side. Originally, beneath this there was a butter and corn market. It also housed the Macclesfield Borough Police Headquarters when the town had its own chief constable and borough police force. The door to the old Borough police station can be found at the side of the building by St Michael's church (see inset). The building was further extended in 1991–92.

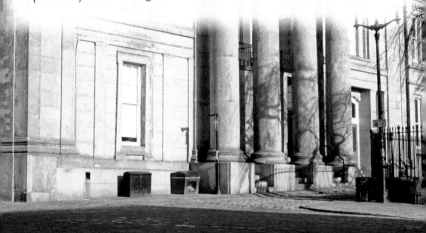

15. CHESTERGATE *c.* LATE 1800s/ EARLY 1900s AND 2016

Looking from the Market Place and opposite the Town Hall we find the ancient street by the name of Chestergate which was once the main road to Chester, and it is worth checking out a few of the notable buildings that can be found there. Firstly, No. 28 Chestergate was originally a house which was later used as a shop; it is a timber-framed building that was built in the late sixteenth to early seventeenth century. In the nineteenth century a brick front was added. The Grade II-listed shop bearing No. 41 Chestergate dates from 1691 and was originally a timber-framed house, later converted into a shop. Nos 50–52 and No. 54 are shops that were built during the seventeenth century and are listed. The shops Nos 115 A, B & C are listed with a building date of the seventeenth century; they were probably one house originally. For centuries the old Market Cross was on the junction of Chestergate and Market Place.

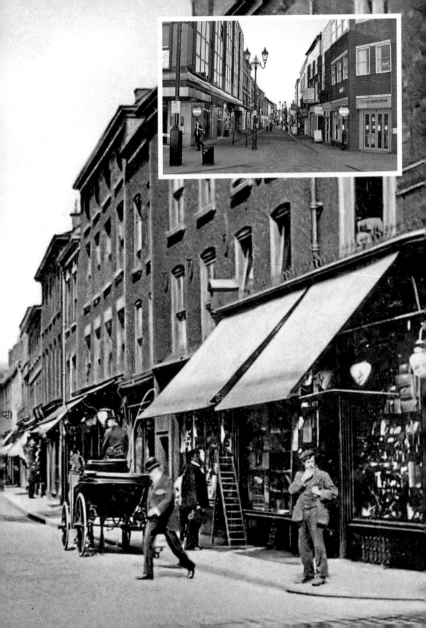

16. THE BATE HALL PUB IN CHESTERGATE 2015

This ancient public house has stood in Chestergate since the sixteenth century. In 1830 a novel was written entitled *The Lost Heir and a Prediction* and in the story the Bate Hall was mentioned and described then as 'an ancient hostelry' in 1622. Within the building there is a Jacobean staircase and other antiquities. It was once the home of the Stopford family, who supported the Parliamentarians during the English Civil War and Oliver Cromwell is reputed to have stayed here. The Stopford family, Earls of Courtown, were landowners in the area. James George Henry Stopford sat in the House of Lords as Lord Saltersford (a hamlet 5½ miles from Macclesfield). The family seat was in County Wexford. 'Beate-Hall', (Bate Hall) was described in 1810 as 'A decayed Mansion, occupied as a public house'. By 1870 it was the Batehall and Peter Simpson was the licensee. There is a priest hole within the building that dates back to Elizabeth I. It was at this time that Roman Catholic priests would say mass in people's houses and be ready to hide if the authorities raided the building. Bear baiting and cock fighting would have taken place in the yard of the pub.

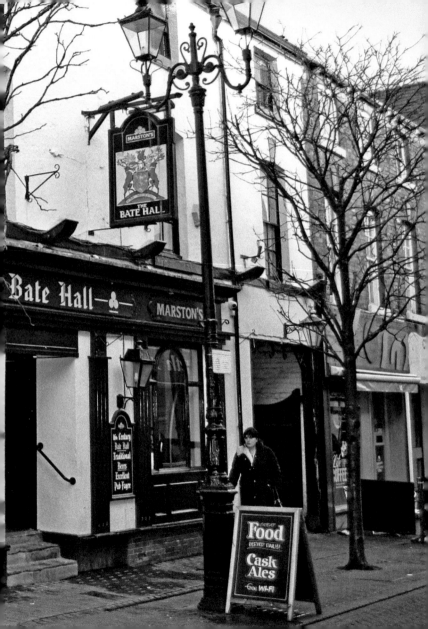

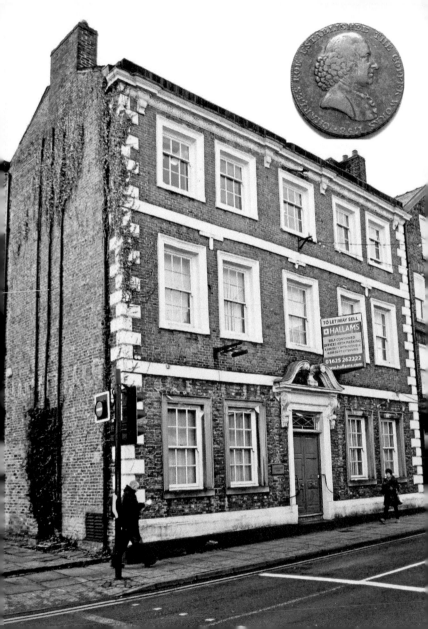

17. CHARLES ROE HOUSE, CHESTERGATE AND A COPPER PENNY

This house was built *c.* 1700 and was later the home of the industrialist Charles Roe from 1753 until his death in 1781. Looking at this three-storey town house gives us the opportunity to look at the famous Macclesfield industrialist. Roe was born in 1715 in Castleton, Derbyshire where his father was the vicar and who died when Charles was eight years old. The family moved to Stockport but soon after his mother also died and Charles and his seven siblings moved to Macclesfield. On leaving the grammar school he entered the silk-button and twist industry becoming a Freeman of Macclesfield in 1742. The following year he built a small spinning mill on Park Green. Six years later, in partnership, he built a far larger mill for the production of silk products on Waters Green. Four years later he was made Mayor of Macclesfield.

Not satisfied with the success in his life so far he started to spread his wings to Coniston in the Lake District and nearby Alderley Edge where he started searching for, and mining, copper. To smelt the copper he built a smelter on Macclesfield Common just outside the town. He then built rolling mills at Eaton near Congleton and at Bosley, initially serving these mills with copper ores from Staffordshire.

At the same time he was extending his own mining operations in North Wales. In March 1768 his workers made a huge discovery of copper on the Isle of Anglesey that became known as 'The Great Lode' and the mine became the largest copper mine in Europe. During 1767 his company Roe & Co. had built a copper smelter on Liverpool's south shore but following complaints about pollution it was moved to Wellington Road, Toxteth Park. He later became self-sufficient in coal for the smelters when he obtained possession of a colliery at Wrexham in North Wales. Mining ceased in Coniston and Alderley Edge and in 1774 the Macclesfield Copper Company was formed with Roe and fourteen other partners becoming one of the three greatest brass companies of the late 1700s. Charles Roe's head was used on Macclesfield copper coinage as can be seen in the inset.

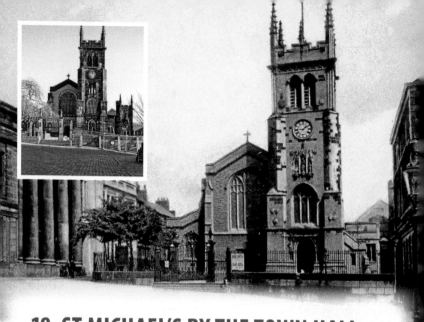

18. ST MICHAEL'S BY THE TOWN HALL UNDATED AND 2016

Back now to the Market Place and sitting alongside the Town Hall on the brow of the hill is St Michael's Church. The parish was formed in October 1835 although the first church on the site dates from around 1220 which is soon after Macclesfield Borough was formed. In 1278 it was rebuilt by Queen Eleanor, the wife of Edward I and it was at this time that it was dedicated to All Saints or All Hallows and was consecrated by the Bishop of St Asaph. Over the years many distinguished families were buried within its walls, and some like Baron Stanley have effigies above the tombs depicting them in suits of armour. The Legh chapel was built around 1442 for Sir Piers Legh, who was killed at the Battle of Agincourt. Then there is the chantry chapel built by Thomas Savage, Archbishop of York from 1501 to 1507.

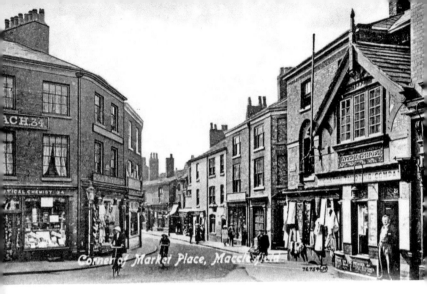

Corner of Market Place, Macclesfield

19. MARKET PLACE INTO MILL STREET
c. 1910

This is a view from the Market Place into Mill Street with the large building housing Isaac Leach Pharmaceutical Chemists at No. 34 Market Place on the left in the photograph. This will date from the turn of the last century. Ye Olde Shop looks a little older than it is as it has the building date of 1897 on the front elevation. In the photograph it was the London Tailoring Company and is now Donald Massey jewellers. There was once a typical medieval market place here with a market cross.

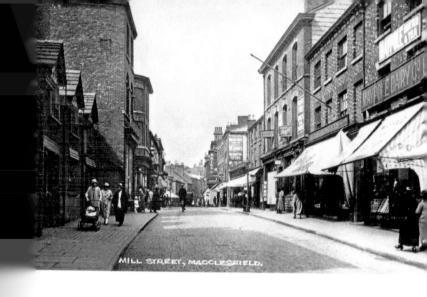

MILL STREET, MACCLESFIELD.

20. MILL STREET *c.* LATE 1800s AND EARLY 1900s

While to its credit, many parts of Macclesfield are unchanged over the years, Mill Street is not one of them, at least at the top end. Fortunately this old photograph, taken at the turn of the last century remains unchanged in so far as the white building on the right in the modern shot is the same one as in the old one albeit that the flag pole has made way for a burglar alarm. Much demolition and rebuilding has gone on here so we will just enjoy the old photograph *c.* 1920s. There is another treasure here though as seen in the inset: the Majestic Cinema with its distinctive white-tiled front. This frontage is still there but leads to a bar. The cinema was built in 1922 and the first film shown was Harold Lloyd in *A Sailor Made Man*. It was the last cinema in Macclesfield to close and when it did so on the 2 April 1998 *The Man in the Iron Mask* was showing.

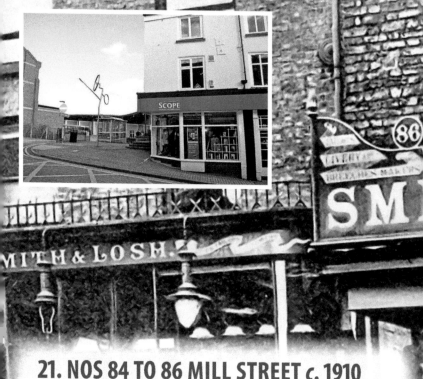

21. NOS 84 TO 86 MILL STREET c. 1910 AND 2016

The name Mill Street comes from the silk mill that Charles Roe opened in Park Green in 1756; this was the first silk mill opened in Macclesfield. The present Mill Street then stretched from Park Green to the Market Place. In 1896 the shops situated at Nos 84 and 86 Mill Street were occupied by Smith & Losh clothiers, by 1934 Harold Willdig a pork butcher traded from No. 86 while No. 84 housed Pullers of Perth, Dyers and cleaners. Today No. 86 is a Scope charity shop. No. 84 spent time as a fruiterers but has now been demolished to make way for the town's bus station.

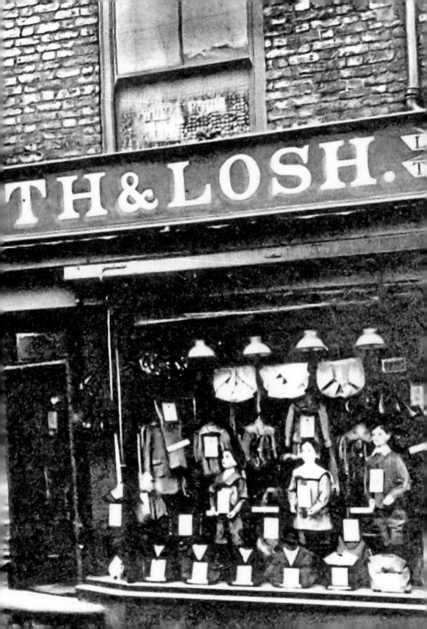

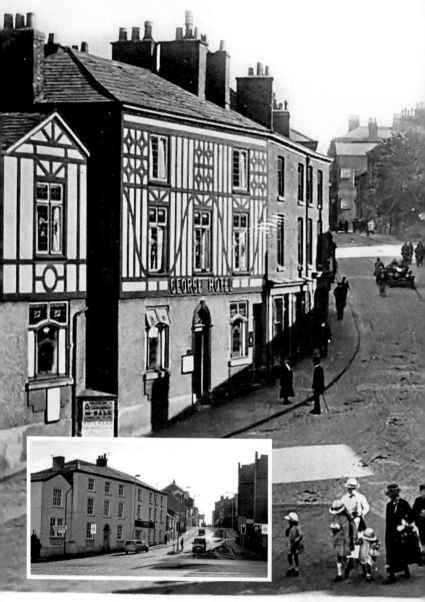

GEORGE HOTEL

JORDANGATE

22. JORDANGATE c. 1920s AND 2016

A pleasant walk now to Hibel Road and down to the junction with Jordangate. Looking down into the latter around the 1920s we see a scene filled with period charm. From the old car coming down the hill to the man about to board a taxi that was 'old' even then. The George Hotel, No. 48 Jordangate has lost its decorative wood cladding and is in fact no longer a hotel or pub having gone the way of many of its peers. It was built in the 1700s and is a Grade II-listed building. It was extensively rebuilt in the nineteenth and twentieth centuries and now contains apartments. The multi-storey car park was a garage and petrol station in those long gone days.

ACCLESFIELD

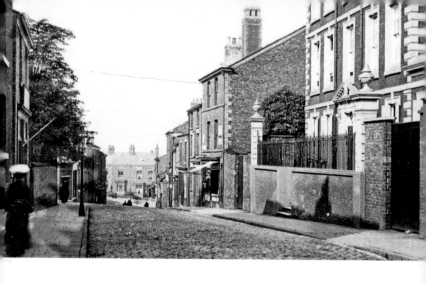

23. JORDANGATE *c.* 1900 AND 2012
AND CUMBERLAND HOUSE

Into Jordangate proper now and towards the Town Hall as we look back towards the junction. This old photograph will have been taken *c.* 1890 and shows a lady in period dress walking down towards Hibel Road. The large building on the right is Jordangate House, once called Pear Tree House, built in 1728. It later became the home of another notable Macclesfield family, the Brocklehursts. John Brocklehurst owned a button-making business. John had a son and grandson, both called John and the latter became the first of two Liberal MPs for Macclesfield. Brocklehurst's Mill was the largest silk mill in England.

Another famous building here is Cumberland House (inset) built in 1723 and almost opposite Jordangate House. It was named such after the victor of the 1745 Jacobite Rebellion, the Duke of Cumberland who stayed here when the occupant was John Stafford the town clerk who is said to have watched the arrival of Bonnie Prince Charlie from the upper windows.

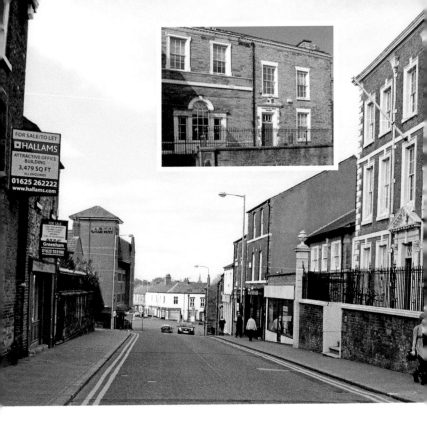

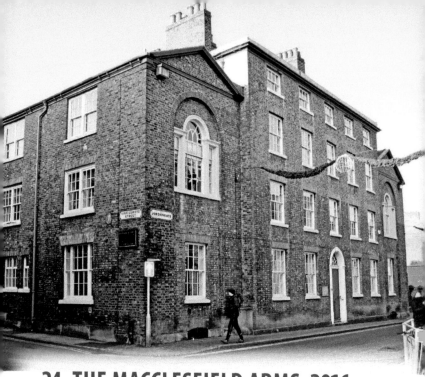

24. THE MACCLESFIELD ARMS, 2016

This old inn has to get a mention in this tour of historical Macclesfield due to its importance over the years. Situated on Jordangate it was originally known as King Edward House. It was built in 1811 and was a coaching inn, one of its past lunchtime customers being the young Princess Victoria (later to become Queen Victoria) and her mother the Duchess of Kent in 1832. They were travelling from Eaton Hall in Chester to Chatsworth and took advantage of the stop to change horses by sampling the inn's fayre. The Royal Telegraph coach left daily for London. Many functions and dinners for the local worthies were held here. As late as the 1970s it was an inn but has now been converted into offices.

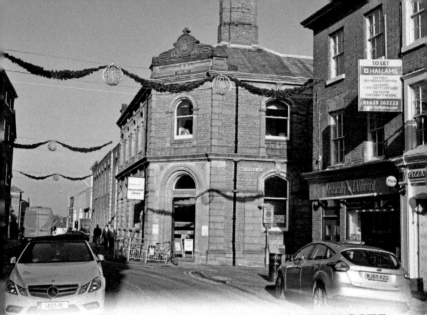

25. MACCLESFIELD LIBRARY, JORDANGATE

Through the early years of Macclesfield the opportunity for the general public to read books was provided by the gentry and the church. In the late 1700s the first of what we could call a modern library was opened on Parsonage Green, later Park Green. It was contained in a gentlemen's club and was for the use of the gentlemen of Macclesfield and their families. Some time after, a library was opened in Back Street, later to be called King Edward Street, Macclesfield. The funding for the library was a bit hit and miss until the Liberal MP David Chadwick provided the money and had the new library built on Park Green as we will see later. The present Macclesfield Library is in the building that originally housed the District Bank on Jordangate. After the building of an extension the library was opened on 28 April 1994 by the Duchess of Gloucester. The extension itself stands on land that once boasted a pub called The Pack Horse.

26. JORDANGATE INTO HIBEL ROAD
c. 1900 AND 2016

A final look now at Jordangate as it enters Hibel Road. Jordangate was one of the ancient gates through the walls into the town and it led down to the River Bollin which in early deeds is shown as the River Jordan. This is one reason for the name. The walls have been long gone but the names remain. The old cottages on the right have been thinned out and the houses on the left demolished to make way for a multi-storey car park. Strangely the building on the right is The Rifleman but I still can find no record of a pub with this name in this location or in the town for that matter.

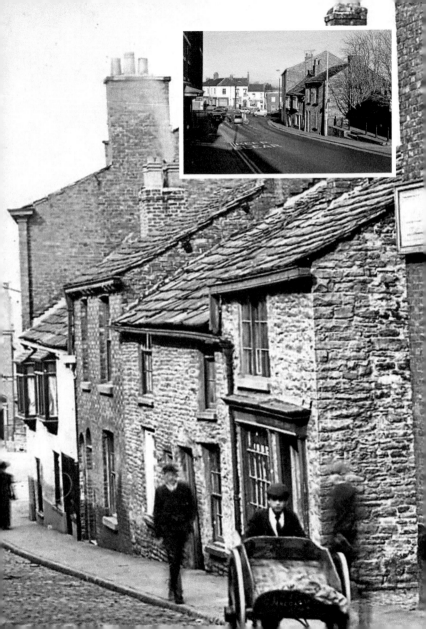

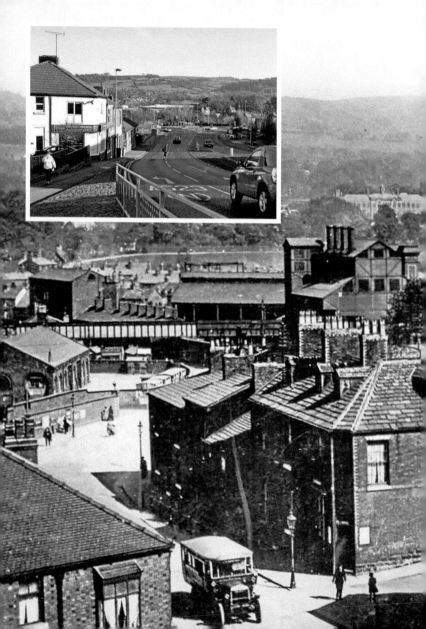

27. HIBEL ROAD c. 1915 AND 2016

The view from the top of the hill is quite hard to replicate due to access problems but this one is not too far out and the old late 1915 photograph is excellent. We look across the railway to what was once the mill buildings and later the short-lived Victoria Park flats. They were built in the awful period of architecture and became a blot on the landscape. Macclesfield's nickname of Silk Town later also became Treacle Town to the locals when it is believed a barrel of treacle was spilt on Hibel Road and the poor of the area rushed out to help themselves. That is one reason; another is that a performing bear loved the stuff and when he broke free treacle was laid as a trap to recapture him. Hibel Road once gave its name to the town's Hibel Road Station.

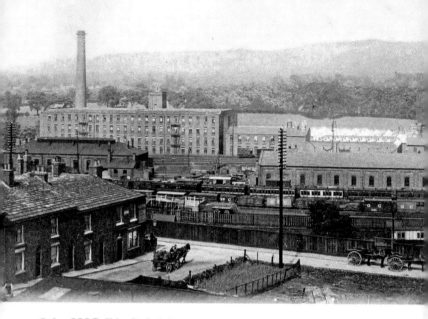

28. HIBEL ROAD STATION c. LATE 1800s

Looking again towards the bottom of Hibel Road we see a better photograph of the old station; down on the left some goods vans can be seen in Hibel Road station. This station was opened on the 13 June 1849 by the LNWR and in 1871 a new station was built by the North Staffordshire Railway called Macclesfield Central. The NSR and the LNWR did not work together but both stations remained open until 1960 when British Railways closed Hibel Road and called the Central Station simply Macclesfield. Hibel Road Station has now disappeared. In the distance can be seen Lower Hayes Mill that is in Black Lane. This was one of many textile mills in Macclesfield built in the eighteenth and nineteenth centuries. This one was severely damaged by fire in the last century but is still there although far smaller. It contains an assortment of small businesses.

29. YE OLDE CASTLE INN *c.* EARLY 1900s AND 2016

This is what the British pub should look like. Built in the eighteenth century as two houses and converted to a pub in the 1900s, it is situated in Churchside. The pub is mainly unaltered both inside and out from those days long gone. It has a maze of small rooms with ornamental plaster ceilings. It is situated on the hill below the parish church which is the good news; the bad news is that like a lot of pubs now it is currently closed. Fortunately Macclesfield boasts more than one true watering hole. As for this ancient hostelry, the aforementioned Macclesfield Castle was originally situated opposite on Back Wallgate and off Mill Street.

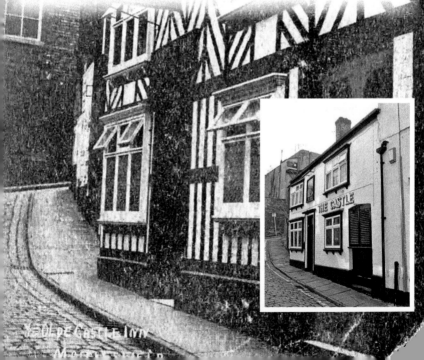

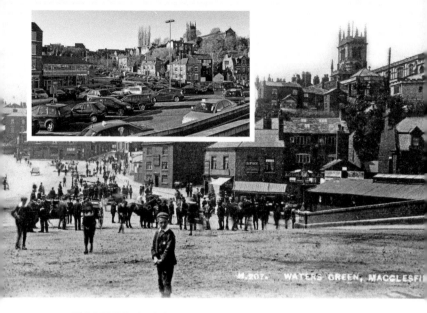

30. WATERS GREEN *c.* EARLY 1900s AND 2012

During the medieval period this was a very boggy area with three streams meandering through it to the River Bollin. These created an island in the middle which over the years silted up; the streams are now controlled with a culvert. It was here in 1748 that Charles Roe and his partners Glover & Co. built a large silk mill complex that was later demolished. This pair of photographs also highlights just how the internal combustion engine has had such a big impact upon our lives. The building of the pub with the round window is displayed in the West Park Museum.

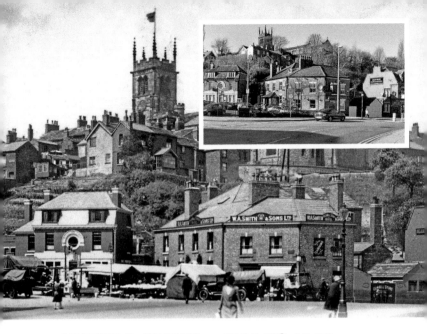

31. WATERS GREEN c. 1930 TO 1940s AND 2016

This very pleasantly named area of Macclesfield has always been a favourite gathering place with its assorted and cosy public houses. There was a sheep and cattle market here until the 1980s. In these two photographs, the reader can just become immersed in old Macclesfield with so many things that have not changed to compare and enjoy. The name Waters Green is a throwback to its wet and boggy days and its shortened local name was Waters or The Waters.

32. ROYAL SILK WAREHOUSE *c.* 1900s

Further along Waters Green now, the area called simply Waters by Maxonians (the name given to people from the town), we find the Macclesfield Travelodge. This building was built in 1903 and bears a date stone RB 1903. It was a silk warehouse, not factory and its products were sold around the world. It went through various different concerns until the new millennium when from 2008 to 2009 it was extended and converted into a Travelodge Hotel. The old photograph is from an advertisement for its products. This building was not technically a manufacturing mill but interesting in its own right in so far as it was responsible for selling Macclesfield's silk products around the world.

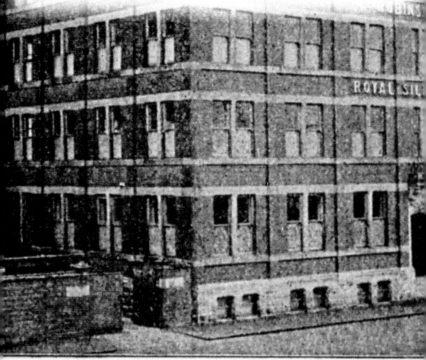

From **ROBINSON BROWN,**

The Royal Silk Warehouse,

· · · Macclesfield.

Date as Post Mark.

Telegrams: "Silkworm,"
Macclesfield.

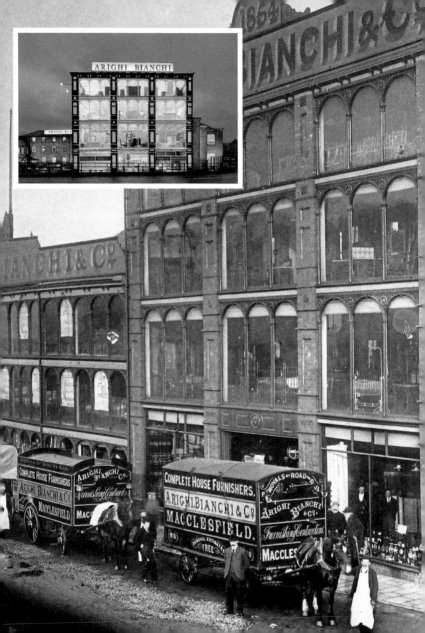

33. ARIGHI BIANCHI STORE

Arighi Bianchi is a long established and quite unique furniture store in Macclesfield, founded in 1854 by Italian immigrants Antonio Arighi and Antonio Bianchi. Mr Arighi was the first to make the long journey from the village of Casnate (a silk-weaving town) on the shores of Lake Como. His long journey brought him to Macclesfield where he started to make clocks and barometers. This business was both successful and lucrative and soon he was joined by Antonio Bianchi, already a successful master craftsman from the same village. Together they created Arighi Bianchi, a bespoke cabinet-making business, making use of what Macclesfield was already famous for, silk and fine fabrics.

It was in 1883 that they purchased the current site and had this quite unique and beautiful shop built. It was modelled on the Crystal Palace in London that dated from 1851, their store being the work of a local builder by the name of George Rylance. It was built as a steel frame and glass building very similar to the buildings in Lower Manhattan, New York. The building was about to be demolished in 1973 but was saved after a campaign by the Victorian Society and Sir John Betjeman. It was renovated and is Grade II listed. The business, that is still family-run, has always had a reputation for high-end furnishings and in the early twentieth century the company provided furniture to Marlborough House and Sandringham by Royal Appointment to Their Majesties King Edward VII, Queen Alexandra and Queen Mary. This reputation for excellence has been maintained through the years and a highly regarded restaurant has been added to the firm's portfolio of beautiful house accoutrements.

34. WESLEYAN CHAPEL, SUNDERLAND STREET

This chapel situated on Sunderland Street was built in 1779 and finally closed its doors in 1969. Another Macclesfield businessman, John Ryle Senior, was a faithful Methodist and provided the land for the chapel but his family did not appreciate his benevolence and decided to worship in Roe's Christ Church. The chapel closed in 1969, became a snooker hall for a while and was later converted to flats.

As for John Ryle, another well-known Macclesfield worthy, he started work as a 'bobbin boy' in local mills in his home town of Bollington and in Macclesfield at the age of five years. Born in 1817, his family had been in the silk industry locally for generations and he was left an orphan at an early age. On 1 March 1839 he immigrated to America and thereafter followed a life in silk production, becoming known as 'The Father of The United States Silk Industry,' and a very wealthy man at the same time. Having been born in Bollington, he returned to the town and died there in 1887 aged seventy.

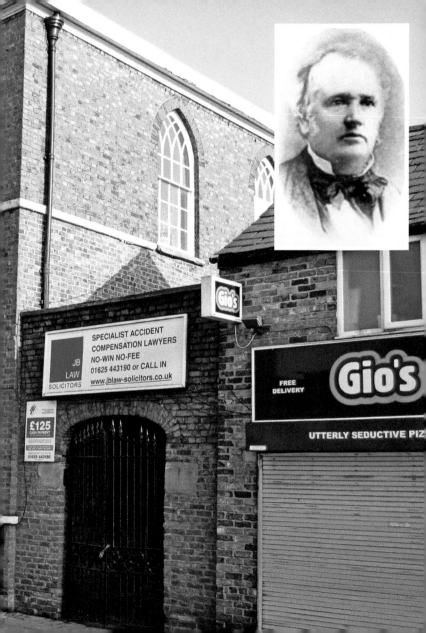

SPECIALIST ACCIDENT
COMPENSATION LAWYERS
NO-WIN NO-FEE
01625 443190 or CALL IN
www.jblaw-solicitors.co.uk

JB
LAW
SOLICITORS

£125
CASH PAYMENT

01625 443190

Gio's

FREE
DELIVERY

Gio's

UTTERLY SEDUCTIVE PIZ

35. CHADWICK FREE LIBRARY c. 1900 AND 2012

The library situated in Park Green (south side) was presented to the town in 1876 by Mr David Chadwick of Dulwich who was one of the two MPs for Macclesfield from 1868 to 1880. The other was William Coare Brocklehurst, a mill owner. It was designed by Mr James Stevens of Macclesfield who also designed the nearby School of Art which opened three years later. Of the 16,873 volumes in the library in 1896 10,000 were a gift from Mr Chadwick. The fountain that the old men are sitting around was built in the 1800s and was dismantled in order for the metal to be used to make armaments during the Second World War. Like a lot of examples of the removal of railings and monuments like this one, it was never actually used for the war effort. There is an almost identical fountain still standing in a public park in Glasgow.

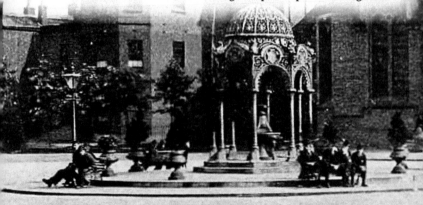

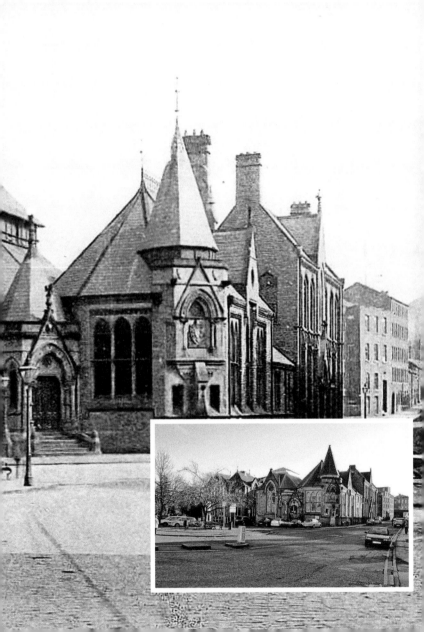

36. PARK GREEN CHURCH UNDATED AND 2014

A look now at the Palladian-style building and the church. Now known as Macclesfield United Reformed Church, it was built in 1877 as the Congregational Chapel, Park Green, having been founded in 1787 in Townley Street. When this new chapel was built the original became a Sunday school. It is still open with a strong congregation. The attractive building next door was built in 1842 and was a bank for many years under assorted banking names, mainly Martin's Bank, and in 1891 the Adelphi Bank. The Adelphi Bank was quite new at this time, having been founded in Liverpool in 1862. In 1899 it was sold to the Lancashire & Yorkshire Bank, now Barclays.

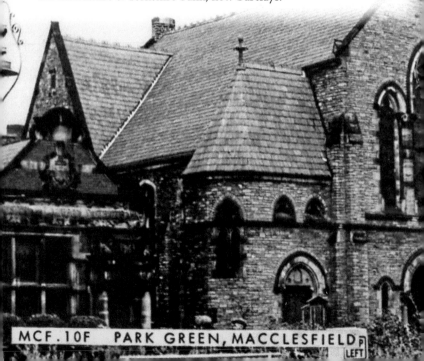

MCF. 10F PARK GREEN, MACCLESFIELD

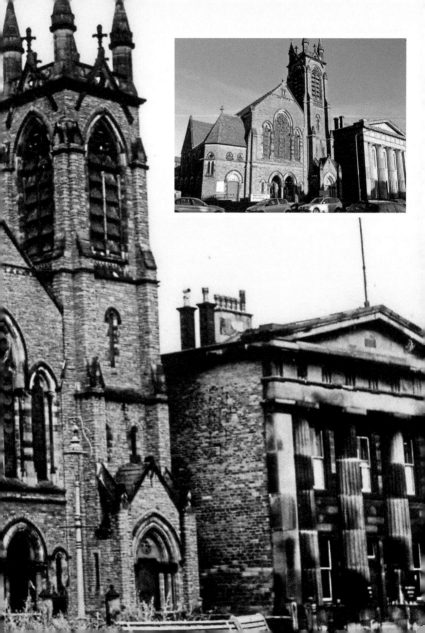

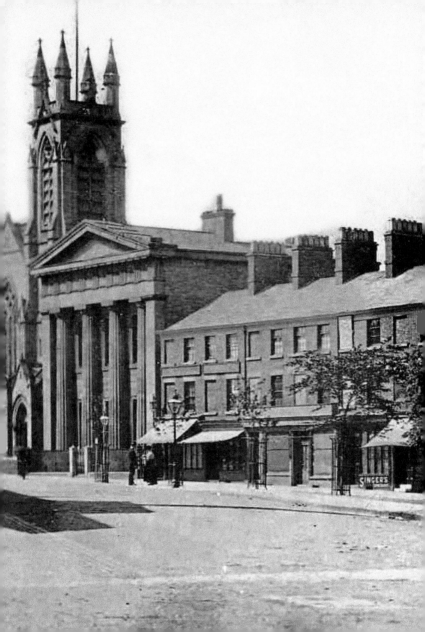

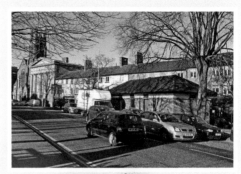

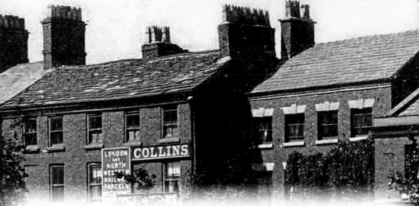

37. PARK GREEN *c.* 1900 AND 2012

Here we look back towards the church; from the Park Street junction the buildings have either been replaced or vastly modernised. What an atmospheric photograph the old one is, horse manure spread liberally on the road in this turn-of-the-century snapshot in time. The Collins building also has a board stating that it is the LNWR parcels receiving office. That is No. 28 Park Green and Walter Collins was a stationers' as well as an agent for the LNWR. The first silk mill was opened in Park Green in 1756 by Charles Roe, hence the main street adjoining it being called Mill Street.

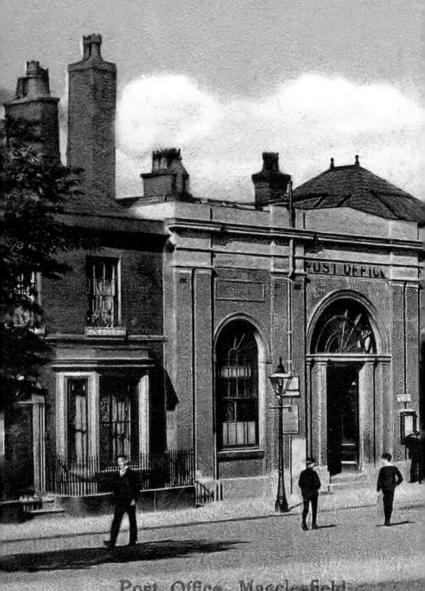

Post Office, Macclesfield

38. POST OFFICE *c.* 1800s

We are now in the Park Green area to see the changes that have taken place over the years, specifically the post office building, built in the 1800s. The photograph dates from around the turn of the last century. It was the main post office building with branches around the town and open daily from 8.00 a.m. to 10.00 p.m. for stamps, postal orders and registration letters and, Sundays 8.00 am to 10.00 a.m. but postal orders could not be sold on a Sunday. Neil Daniel Stewart was the postmaster. Demolished in the twentieth century, it was replaced by a block of shops. The one on the post office site became Macclesfield's magistrates' court.

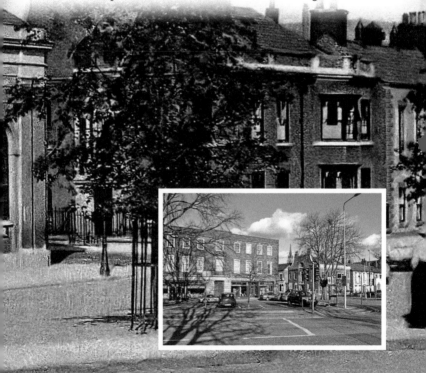

W. H. Serle

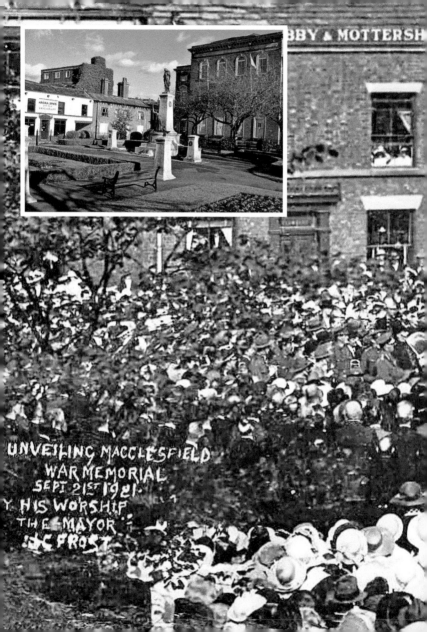

BBY & MOTTERSH

UNVEILING MACCLESFIELD
WAR MEMORIAL
SEPT 21ST 1921
Y HIS WORSHIP
THE MAYOR
J C FROST

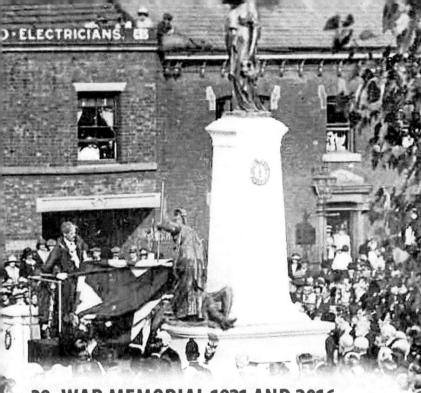

39. WAR MEMORIAL 1921 AND 2016

This memorial to those fallen in the First World War was unveiled by J. C. Frost, the Mayor of Macclesfield on 21 September 1921. The crowds gather and the band plays, but little did they know that in less than twenty years another world war would start and more names would be added to the memorial – and sadly are still being added. You can see the main column with the two stone plinths at either end of the curved wall, each one carrying a bronze inscribed plate. Four freestanding pillars bear the names of the dead of Macclesfield. Over the years and on to the present day, we owe our service men and women so very much.

40. JAMES STREET *c.* 1900 AND 2012

Now to an example of a 'garret house'; these were three-storey houses built during the eighteenth and nineteenth centuries and some had outside stairs. They were built for the handloom weavers who would use the upper floor to work; this floor as can be seen in the photograph was well lighted by virtue of the large window area. Although not usually used for their original purposes, many houses are still standing in Duke Street and other areas in the town. A lot can also be identified with the pillared doorways with pediments or fanlights. In many cases, the master weaver would live in the house with his family and apprentices. In other garret houses, the garret would run the full length of a row of terraced houses in which all of the residents worked.

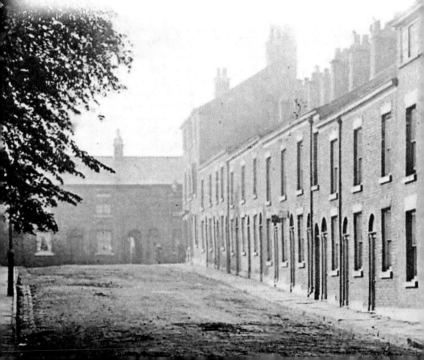

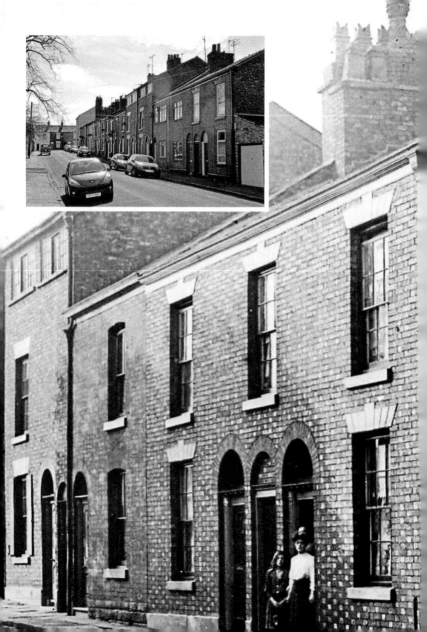

41. PARK STREET AND CHAPEL c. 1900

Into Park Street now and looking towards the new roundabout at Churchill Way and thence to Park Green where we find the Park Street Chapel. This area is where Park Lane becomes Park Street. The chapel was built in 1836 and opened in 1837 as the Methodist New Connexion Chapel. The words can be seen on the raised ornamentation at the front of the roof, it cost £4,500 in total and is now no longer a chapel but has been converted into apartments. This section of Methodism broke away from the main body in 1797 because they wanted more power given to laymen; it was one of a number of offshoots from the main religion for mainly differences of opinion in the teachings, and in this case they called themselves New Connexion Methodists. There have been many changes at this location over the years with the end of Park Lane dissected for the purpose.

We stand in Park Street looking into Park Green and towards Sunderland Street, across the War Memorial to the church of St Paul's in Glegg Street. The church was built in 1844 at a cost of £5,400 and has a commanding view over the town. Unlike this chapel and several other churches in the town, St Paul's is still an active and vibrant parish a well-known Macclesfield landmark above the town's landscape.

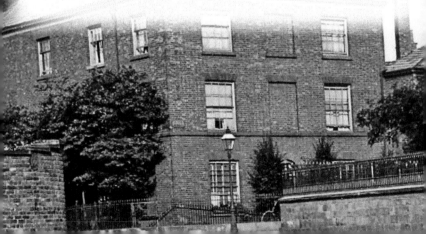

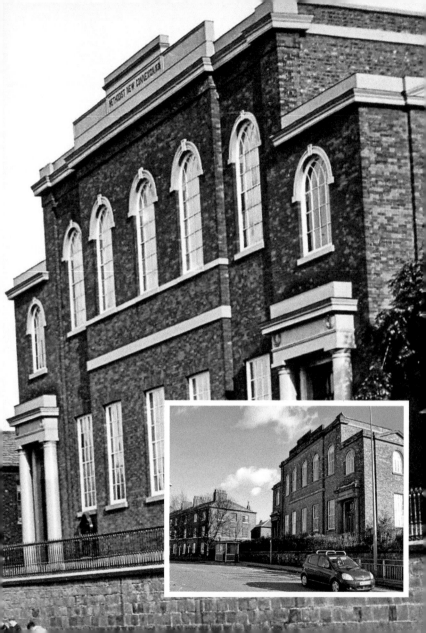

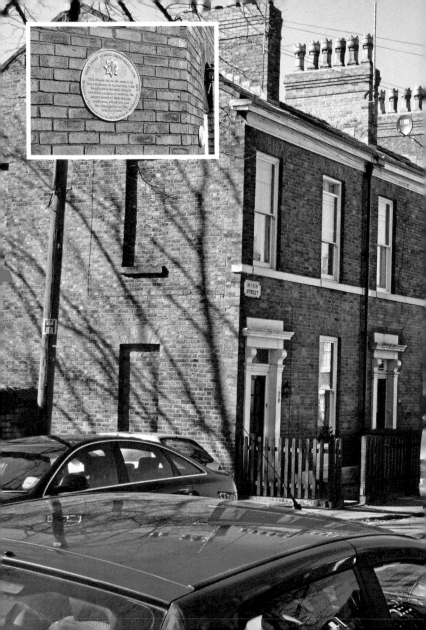

42. HIGH STREET c. 1900, BLUE PLAQUE

At the rear of the Park Street Chapel we find Macclesfield High Street. In most towns the High Street is filled with shops and is the main road in the town. In Macclesfield it is a haven of peace with its old terrace of good-class dwelling houses, terraced houses, houses with former weavers' garrets built in 1830 and courts. Once a long street leading through to London Road, it contains a number of listed buildings including the church of St George that was built in 1822 and is still there. It was closed as a church in the twentieth century and is now used for offices. It is also a remarkably well-kept area where the local residents have joined with the council and other agencies to make their streets and houses a perfect example of good management. A blue plaque was erected to celebrate this that can be seen in the inset.

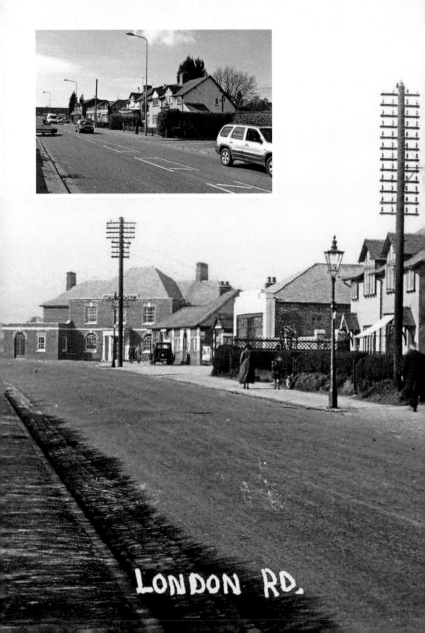

LONDON RD.

43. LONDON ROAD *c.* 1930s

A trip out of town now from the High Street and Park Green area, we come to London Road leading out of town and we arrive at its junction with Lyme Avenue. The large building in the far distance in the old photograph has now gone and the Moss Rose football ground, home of Macclesfield Town football club, is in its place. The team was formed in 1873 when the 8th Cheshire Rifle Volunteers played their first match. Three years later they combined with the Olympic Cricket Club who also used the pitch and the club was known by a succession of names, including Macclesfield Football & Athletic Club and Hallifield FC. In 1891 the team moved to the Moss Rose ground. They are at presently in the Vanarama National League.

44. IVY LANE CORNER *c.* 1940s AND 2012

This once quiet lane leads from Chester Road through to the junction with Park Lane, Congleton Road and Oxford Road. From Chester Road to this location the road is called Ivy Road, changing to Ivy Lane here. In the old photograph, the lane reaches the crossroads in a 1940s' photo filled with period charm. It is not, however, a corner but a crossroads with the bicycles coming out of Ivy Lane; Park Lane would then be straight on and Oxford Road to their left with Congleton Road behind the camera. Much road widening has been carried out here and the large shop has gone, although the houses behind it are still there.

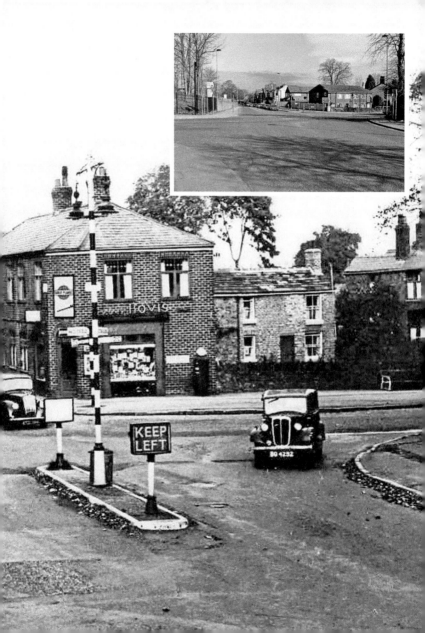

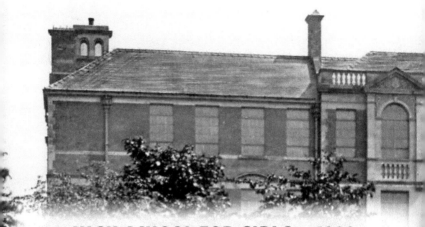

45. HIGH SCHOOL FOR GIRLS *c.* 1900 AND 2012

By the late nineteenth century it was discovered that education for girls was being neglected in the country. In Macclesfield it was suggested that a high school specifically for girls would be a good idea; the Useful Knowledge Society in Park Green already provided facilities for teaching and it was decided to turn the premises into a school for girls. In 1902 the Education Act allowed for the building of a purpose-built girls' school in Fence Avenue on the site of a house called The Fence and owned by Mr Charles Brocklehurst. This school opened its doors to the girls of Macclesfield in February 1909 and in 1980 became a mixed state comprehensive; it remained open until 1990 when it was forced to close. This beautiful building was then left in a neglected state for two years until taken over by the King's School Foundation. It is now the girls' division of the King's School.

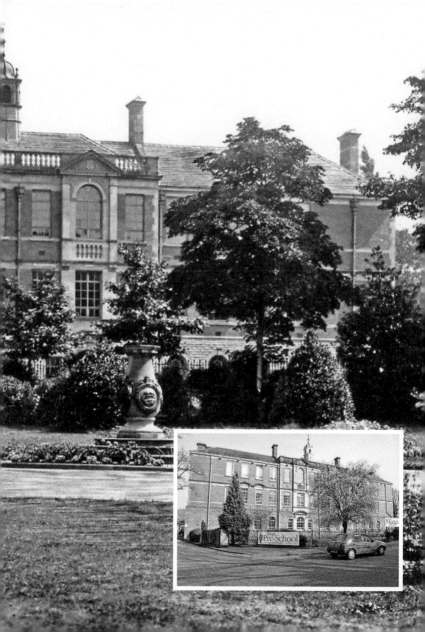

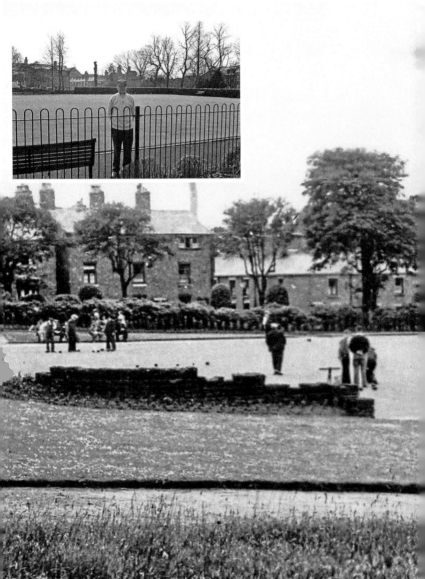

CTÓRIA PARK, BOWLING GREEN,

46. VICTORIA PARK BOWLING GREEN

Victoria Park was opened in 1894, not long before the girls' school, now the King's School, over the road. The photo of the girls' school was taken from Victoria Park that has the address of Buxton Road. This photograph shows the bowling green in the park and the man in the picture is an old Macclesfield resident by the name of Frank Talbot. Mr Talbot was able to provide me with a potted history of the area and for that I am grateful. The park has, as well as a bowling green, a bandstand, aviary, lawns and flower gardens. It stands on land that had a large house on it situated in what is now the girls' school. The house was demolished to build the school and the land for the park was given by the Brocklehurst family, amounting to 13 acres. There is a monument within the park thanking Francis Dicken Brocklehurst for his generosity.

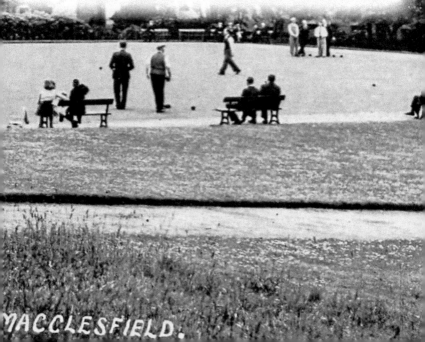

MACCLESFIELD.

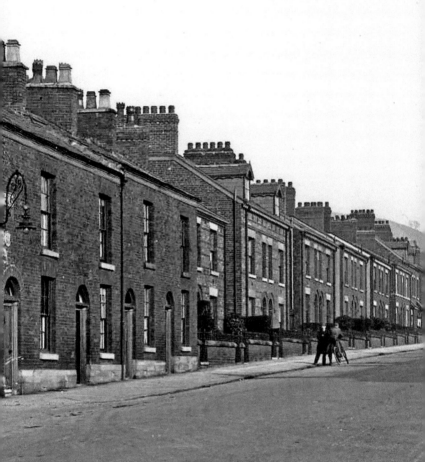

Higher Buxton Ro

47. HIGHER BUXTON ROAD c. 1920s

We now continue up Higher Buxton Road in the direction of Buxton and the Cheshire Peak District. Barrack Lane can be seen on the left, the home of the strangely named Puss Bank School. Continuing along this road takes you up on to the moors and eventually to Buxton via the famous Cat & Fiddle pub, the second highest in England. Another sad statistic as that road to Buxton has been classed as the most dangerous in Britain, especially for motor cycles.

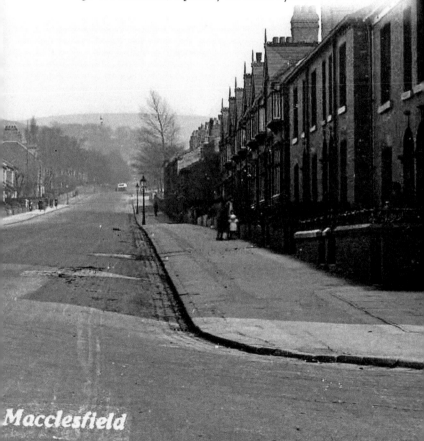

Macclesfield

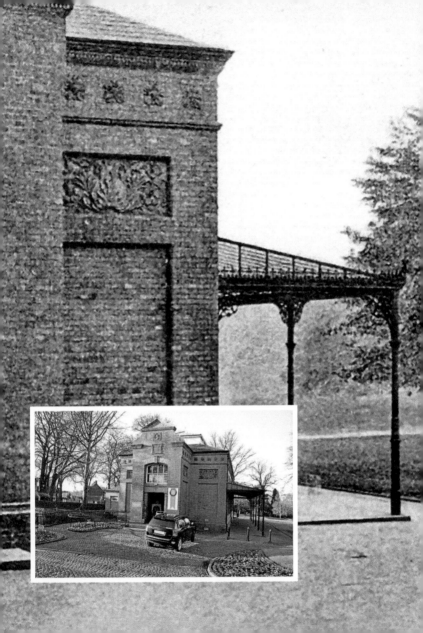

48. WEST PARK MUSEUM *c.* 1920s/1930s AND 2016

West Park was opened in 1854 and was the first public park in Macclesfield. Then in October 1898 the museum was opened to the north of the main entrance, donated by sister and brother Marianne and Peter Pownall Brocklehurst. In 1904 a bandstand was purchased, mainly by public subscription, to celebrate the park's jubilee. This was demolished in the 1970s and replaced with a cycle track. The park was originally called Peel's Park as a tribute to Sir Robert Peel but was known locally simply as 'The Park'. Outside the red brick building, the covered seating area is still there although the seats have now gone, and the park has changed from a select area in which to take the air on a warm day to a modern view of a skate park. Things have to change but what has not changed is the museum and its excellent and helpful staff.

49. WEST PARK WITH ROCK

The boulder seen here mystifies many as to how it got here. Originally it will have been carried from Ravenglass in Cumbria, by the movement of a glacier during the Ice Age, and deposited in the sea that covered Cheshire. This particular rock weighs about 30 tons and was presented to the park by Mr Joseph Beswick on 24 July 1847, shortly after the park opened. It had been recovered from a field near Oxford Road. Here in this final photograph of the park, in its more leisurely days, with the sunken Bowling Green and the church spire in the distance. In 1857 two Russian guns captured in the Crimean War were displayed in the park but these were removed in the Second World War.

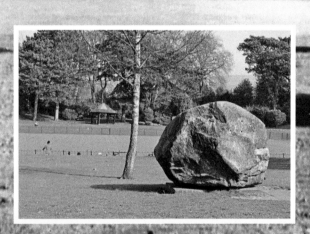

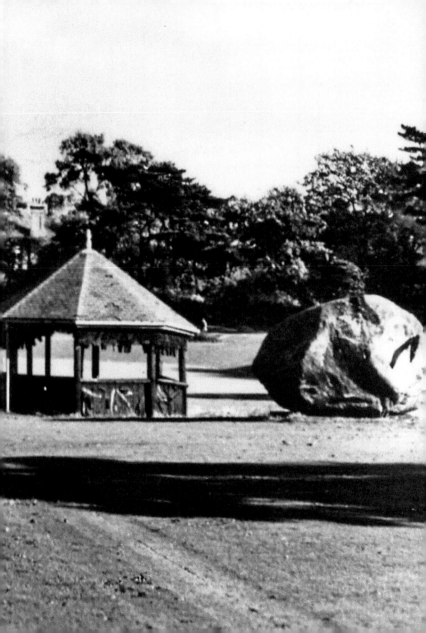

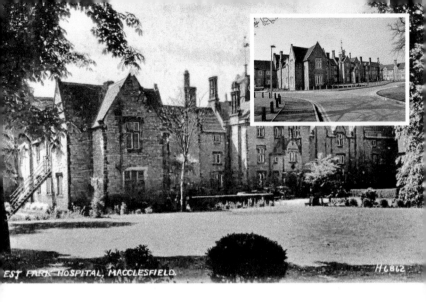

EST PARK HOSPITAL, MACCLESFIELD. H6862

50. WEST PARK HOSPITAL c. EARLY 1900s

Built originally as an institution and workhouse in 1843 to 1845, it was designed by the firm of Scott & Moffatt of Spring Gardens, London. Scott went on to be the famous architect Sir Gilbert Scott. The new workhouse could house 500 inmates and had replaced one that was no longer fit for purpose, especially in view of the new laws that came into force regarding workhouse conditions. It was built to cover the whole of the Macclesfield Union. The sexes could be separated as could the able-bodied, sane and 'imbecile'. However, while the squalor of the old workhouse was improved upon, wives and husbands were split up as were both mothers and fathers from children. In 1929 its workhouse duties were over and from then until 1947 it became the West Park Hospital. Then from 1949 to 1983 it was Macclesfield Hospital West Park Branch after which it became and remains Macclesfield District General Hospital, West Park Branch.